ROSSITSA KOPUKOVA

HALLOW, LIGHT

FROM THE PURE SOURCE

№ 1

Hallow, light – lyrics, novels
© Rossitsa Kopukova – author
Artist: Kalina Dimitrova
Graphic: Toshko Martinov
Redactor: Katia Novakova
Corrector: Tzvetelina Dimitrova

Lulu.com – 2011
ISBN 978-1-4475-0604-1

Second edition Lulu.com – 2015
ISBN 978-1-326-20285-9

Contact:
Sofia 1309, Bulgaria,
Zona B-18, bl.10, et. 3, ap. 17
Rossitsa Kopukova

ROSSITSA KOPUKOVA

HALLOW, LIGHT

Lyrics
Novels

Translated by
Diana Arnaudova, Nata Ermenkova
and Julijana Dimitrova

Lyrics

HALLOW, LIGHT

LYRICS

The play of the wind

The wind makes illusions,
Cheats my thirsty spirit
And puts on my body
Thrills like a fluff.

I do not believe in motions
That are made by the wind,
I run from intoxications,
Do not want to be involved.

I am running, but still staying,
Going to, but do not walk
And I have a feeling,
As if the whole land is watching me.

There, where I am looking back –
There is a wind,
Like a fairy game,
That ends in the morns.

Your role is very pleasant,
The time has stopped here,
Then everything is over
And goes to somebody else.

The wind makes wonderful
Roles, feelings, colors
And the sky takes me up
And all the sins are over.

That's why it is pleasant for me
To be in its illusion world
And I stay here, unbelievable,
By its illusive face.

June, 7th, 1992, Sofia

* * *

There is a small child in me,
That is from my childhood,
It lives in the depth
Of my grown-up soul,
It jumps like a boy,
It's exited with joy,
It laughs childish
At every danger,
It doesn't know
Any crises and terror
No wounds, no cries,
I have a dwarf-saver,
Given to me by the God,
I have no fear, no sufferings
Of my senses,
Nothing is becoming older
And has any pain in me.
The whole world becomes wiser
In honor of a glory,
And I have this glory
Due to my dwarf.
Sometimes I arouse envy,
But my dwarf protects me.
May it please God
It is in most of the people.

October, 6th, 1992, Sofia

The spring of inspiration

The illusion gives birth to inspiration
For something special. It gives a magic
To every earth dimension.
The part of a god likeness appears.

By the change of life's layers
The illusion is slowly melting
And the inspiration goes away,
But not the god likeness's part:

Given birth to a poem, a sound, an image,
Just given birth to its gold creation.
Till the next meeting with an illusion
And an inspiration, giving a file.

Why should we blame the art's creators
That they are always changeable:
They are living eternally with the feeling,
That they are in a universal lightness?

The transition of every depressed ideal
Resounds in them most of all.
But there is another one. And in its way
To the eternity the uninspired
Wouldn't have survived.

June, 23rd, 1996, Sofia

* * *

The proved truth hurts
More, than lies, sometimes,
The wins taste bitter –
It were better not to have them.

And facts, that became obvious,
Have no possibility to die.
And words are dying from the blame,
But can't remove the trace.

The proved truth hurts,
Burned mistakes scatter.
The circle is over. And the way begins.
And the risks to survive again.

I doubt what they would save.
On the brink of an untold lie.
On the brink of a closed wound.
The proved truth hurts.

November, 20th, 1995, Sofia

The pearls' mystery

Where does a pearl live?
In a mussel.
When does it shine?
When it is opened.
And its mystery shining
Is for to capture
Without speaking,
There are too rare mussels are around us,
The time of sea comparisons has gone.
But kept for centuries
The pearls live in prisons.
And you must be looking for them
And open – they are still shining
And still living in the pearls
And still are not changing their place.
There are just can't be found other where
All the rest is a luxury game,
An illusion,
A lie.

June, 20th, 1996, Sofia

Before waking up

Before to open my eyes
I feel the color of the light,
That sent tenderly,
Noiselessly,
With a fairy kiss
Its brother – the darkness.
And I wonder
Why are we running?
Scared from the darkness?
It's also a nuance
Of a rainbow.

June, 20th, 1996, Sofia

The spring wind

To the Poem I would walk on foot –
Not by the dashing age-old troika..."

Natalia Ermenkova, "Lady Autumn"

In the poetry I walk on foot,
Not in a beautiful carriage – and – three
I go with a risk to break the world order
And to get wounds on my hands and knees.

My poetry is a light,
By not an immaterial illusion of the soul,
The selfish writer does not walk on foot
In a Poetry.

The all – times carriage
Carries epoch's servants,
But I am earth-born, strong and lone
After poems, doubts, ideas…
In the poetry I walk on foot…

1997, Sofia

Spring wind

A spring wind rushed though the window this morning
And with a smile it whispered to me to wake up
And it moved words, papers,
A typewriter – everything around
And hinted charmingly, that is looking at me
 And is wondering.

The facts, long-waiting for the words, are on my table,
And I, like in some daze, walk by them
 And just go on living,
And the moment goes away, the day's wheel spins
And I just have a feeling I can not become older.

I should do some analysis. Some report,
 Consolation for someone
Who is waiting for it? It's the turn of revenge
 And nemesis
And the wind says to me: put on your spring dress
And write, and walk, and create,
 But don't be in no-time.

And it spilled all around a light.
And gave me a godlike strength.
And the pieces of belief gathered
 In a nimbus of a lovely magic.
Elated, I have understood,
 That the room with a freshness fills up
And bewitches all around that wind – Messiah.

June, 15th, 1997, Sofia

Evening prayer

The wind becomes quiet in the twilight.
There is a feeling, that all are preparing
 For praying –
A tree, a bird, the last passer – by,
And somebody's blessing flies
Over us in the divine world,
In a silent space
Blessed is the twilight,
United the nature and the people.

In the numerous number of the stars
We feel ourselves very small, small…
And only though the prayer sign
We reach our eternity.

January, 25th, 1998, Sofia

The colors of love

The queen-love is changing:
Till twenty it's tender pink,
Till thirty it's exiting violet,
It's sober green till forty,
Over fifty the brown wisdom
Makes itself the way to the future.
But a drop of pink remains till death –
And this makes the sense of our existence.

September, 23rd, 1999, Sofia

* * *

A family-tree would not forgive you,
If you will break a branch
For to hidden it.
It will strike a root,
A tree will grow
And your illusions
Will be broken.

October, 2nd, 1999, Sofia

* * *

I don't like black words.
I don't like black cloths.
I don't like black souls
And an over coming pessimism.

I believe in a colored day,
In the nature only the soil is black,
But to give a birth the green grass grows
And the wonder of colors appears.

October, 2nd, 1999, Sofia

* * *

The pseudo friend,
Welcome!
Wash the flat of your hand
From false sincerity,
Don't give me a hand –
Don't be in a hurry, I see you
And will give you just nothing.
My sole is a stone,
I know,
When it is worn out with the falseness
And aims exactly
As with a sling
To your forehead.
Sometimes it revenges
For a handful of the evil.
Come on and see
What are you
Deeply in my eyes.
Don't wait to aim you.
We will spoil the fine taste
Of the deception.
Just go away.

October, 2nd, 1999, Sofia

* * *

Tell me about this country,
Where there is a love and a harmony,
There are no attacks, no wars –
Let name it – the land Loveslavia.

There we are together. What a dream,
What a long waiting for centuries –
Unreachable, but always wished
Perfection. Just tell me.

How a man feels himself without intrigues
And without envy, without evil?
May be you are that Universe,
That tender, beautiful land.

But will you manage in the time
And on the sinful earth
To survive yourself in freedom
And to keep your live till the end.

October, 12th, 1999, Sofia

Sky city

There is a sky city Marrakech,
Where the artistic Bohemian
Is taking delights cash
From the ancient times till nowadays.

The life there is pulsing, not flowing,
Oracles and Magi foretell
The fate not for years, but for hours,
It's overcrowded around, and Marrakech

Tells itself about its magic,
It calls for a drink every day,
Keeps you awaken, fresh non-stop,
Its being is never tired.

And lying on a Moroccan carpet
Made with the inherent warmness,
You have a feeling of a flight in heavens,
Dazed by the beauty and delight

And in this faithful to the God city
The worldly goods are too well known,
Reminding you that you are in this world,
Though you could hardly make difference

Between the rich and the poor,
 This is their style.
And I would call it right-minded.
But those, who have ever been to Marrakech,
Are said to dream of it forever

Made as if from a sky's donation,
It is built as though by the hand from on high,
For talents its vocation is to this day,
Marrakech goes on living with it's Past.

October, 6-7th, 2006, Sofia-Pernik-Sofia

The autumn fall

The leaves are falling down in front of me,
A handsaw sings,
The neighbor is preparing for the winter
But there is still the summer breath

Vibrating in the air,
A beautiful mountain
Is putting down its dress
And is waving tenderly.

The moment for a balance comes,
For autumn's retribution,
My face looks different
Against autumn's background.

October, 4th, 2006, Sofia

Erato

Erato, you are an eternal muse
Of love – healing and magic,
Does a modern woman understand
How much you are still required?

Because without love a spirit is dry
And windiness blows in business – days,
Erato, give to everyone a clear sight
And lightness, warmness in his eyes.

Erato, I appreciate you very much,
It is you, who blesses my poetry,
Are you gifted with a God's sparkle –
Ancient and new for ever.

I don't know it, but I am sure,
That every man needs his Erato,
And that the glow of love
Is much more beautiful of the gold itself.

October, 9th, 2006, Sofia

Honor

Only the God himself
Dictates me my poems,
And I write, and honor him
And thank him every hour.

It's just his wonder will,
That gave me the talent,
And I pray to God
To be healthy and happy.

I am not touched by envy in any way,
Because I am chosen by the God himself.
I am eager to make the good
For everything, that He gave to me.

I wish all the mankind
To live in peace and beauty.
Every my creative work
Is due to the God.

October, 21st, 2006, Simeonovo – Sofia

A yard in Simeonovo

Squirrels and running
Only in my yard,
I know, that it smells
On alder and pine.

Crickets sing
Only in my grass,
Birds are waving for me
A silver birch.

And a white poplar
Knees to me,
Cypresses are looking high
In my blue – blue day.

You are asking me
What is all his beauty for?
Without cement and pavement
I am standing in the yard.

My country – house is without
 Stone – walls
And stressed concrete.
My yard is a paradise, a gift
And a house for birds.

October, 21st, 2006, Simeonovo

Love, Love

Love, love, all – powerful of time
And a delight of every day,
You give the lightning inspiration,
The wings and courage to a man.

Without you the people look like robots
Without spirit and without color.
The tarts – the working lay figures
– Dream not to be on the pay – roll.

So inconsistent with banalities,
Vulnerable to life's new jokes,
You are still wanted, irresistible,
Wished, uninvited love.

It's hard to him, who never had you
And him, who lived without you.
But even he was hoping to meet you,
Though without joy he has survived.

October, 24th, 2006, Sofia-Simeonovo

Learn Your Lesson on Earth

The gap you fell in won't forgive you.
So tell the truth with no reserve.
Yes, tell it, though the wound may hurt.
However, time will heal, and make it white.

POEMS ABOUT ELENA ROERICH

* * *

You are not a goddess, you are just a wife,
But you have inspired all due to the God –
Your husband and your sons, and light
Above all people you did spread, beloved.

Your intellect is brilliant, you are a wife
For work of talent, you are a mother
 And a stimulus,
You are a chosen by pure spirits subject,
A wife, born for the highest
 Missionary aims.

* * *

You are an inspiration for Nikolay,
You are a magic of a female petting,
The world for you is like a paradise,
And you for him – a noble painting.

How have you gone your fire way,
"AGNI JOGA" how ere you writing? –
Wondered all the world – and does today,
And with him with admiration
 I'm wondering…

* * *

The New era herald you are,
Gifted with oracle visions,
Not only your beauty is shining, –
Your spirit is called to brighten,

Your spirit is called for peace and work,
For science and for humanity,
It's called to forgive the others' sins,
It's called to convince with its wit.

* * *

You ask your teachers
How to get rid of some vices,
And they answer: "Be kind-hearted," –
Giving no boring lessons.

Together with the mahatmas you touched
The mankind with the jest of kindness,
And with your courage crossed the world,
Keeping your head up, without touching evil…

* * *

Elena, you were not a god,
But Nikolay – he called you "Goddess".
A cosmopolitan. A human-being,
Who of thousands of women got ahead.

You opened the dreamed door
Yourself, in the era of Aquarius,
You were the "Water-carrier" and so
The world was your own home…

* * *

You crossed the continent all around,
Traveled five years in Asia with caravan.
And spread from the Universe all about
The messages o all bright powers.

At last you stopped in India,
Captivated by the Himalayas beauty
Falling in love with this fantasy land
With its fairy-tail secret dedication.

* * *

You worked for Buddha,
 For re-opening his wisdom,
Accepted him for Teacher, re-creating,
Spiritual relationship with India
Became the Universe immensity.

You, a philosopher and a musician,
And India – a secret and enchantment,
You, with your bright compositor's talent,
And India – a path to the infinity…

* * *

You were a helping hand –
For kindness, work and wisdom –
The truth about Blavatsky came over you,
You cleanse from a sin everything, lighting up.

You were a guiding star,
And shining you overcame all human misery,
And war, and all defeats,
Because you heard the angels sounds…

* * *

Visions and dreams to you
The sky powers sent for years.
You outlived your own life,
And now you're again a hope.

What is the world without light,
Without universal beauty, faith
In the new norms era,
New principles and new criteria…

* * *

In the conflicts of earth hostility
Dies everything false and banal,
For to stay the fire trace
Of the most elevated things.
For common survival!

* * *

Elena, you are an example
Of what is the sense and value.
Let all over the God's world
The people of different nations see again.

The 12th of February 2003, Sofia.

The poems are written on the Birthday of Elena Roerich, born on the 12th of February 1879, in Petersburg.

THE POEMS ABOUT THE ROERICHS

* * *

The life is a sensed beauty
And a light, that shines everywhere,
The life is a fulfilled dream
Of the whole family, that remains here.

It is an example, given by the Skies,
And by the God himself to all the mankind,
How to make sense of every new day,
Never saying: "No, I can't".

* * *

Mahatmas were good teachers,
They were Helen's guides,
They inspired her to work creatively
And to write down the saint philosophy.

She was ready to burn
In the flames of her Universe way,
But they stopped her, just saying: "Don't!
You shouldn't burn, it makes no sense!"

* * *

She, beloved by her husband and sons,
Their inspiration and their star,
Subjected to the other worlds,
Took the bridles of he fate in her hands,

She guided the family caravan,
Sure in her universe mission,
Making her life plans,
Throwing away her fears in any weather.

* * *

The beautiful is always good!
The good brings always beauty!
And Elena Roerich isn't any goddess,
But she created the live ethics,

And she remains forever in this world
Beloved by thousands, by all the people,
For her blessed womanliness,
Who consider her a real guide!

And in the pictures, made by Nikolay,
She is the only muse, the only love!
She's undivided from her family paradise,
So real and so irresistible…

* * *

She crossed the world headlong –
With beauty, struggle and dynamics,
Helen did leave the trace,
She showed how to be a personality!

The 11th of March 2003, Sofia

The dreamed town – Zvenigorod

Reached the heart of the Altai,
Communicated with the Universe and God
The Roerich family made in this sun paradise
A project for Zvenigorod.

The town – dream, from fairy – tails,
Of light and science and cognition,
A wonderful micro – world,
A spirit house in the universe.

(From the plot of N. Roerich's picture "Zvenigorod")

* * *

Born in the picture of Nikolay –
There is a top near a temple for all common people
For this town to be blessed by the God
And by all light spirits,

In order to become a town of future and wisdom,
There, at the foot of Beluha,
The blessing for the generations
And a gift without common passions and destroy.

* * *

And came the promised help,
But Zvenigorod was just an idea,
Without continuation, at that time,
When the future could not live.

The idea came back now,
Inspiring with its great power the creators,
Because the victory of a spirit
Stays after the outrage of the blind men.

* * *

The Sun town, the wonderful town,
And probably we won't see it in our life,
But in this fascinating and rising town
There shines a great mission.

Today, at this very moment,
I wrote my flying poem, on the eve of Aquarius,
Touched by The Roerichs, I decided
To give my poetic sparkle of the faith.

The 8th of April 2003, Sofia

A PATH FROM THE EAST
/11 poems about Roerich family/

* * *

There were three wise men,
Yuri, Nikolay and Svetoslav –
The farther and his sons-priests,
They took a bright powers' path.

Born to be above the common world,
Together with a priestess Elena,
They knew no language borders, no walls,
That were built of mental barriers.

They came as a kind of astral light,
Leaving a massage with words.
What was a death for them?
A transference on the ways of the God.

* * *

To Yuri Roerich

He was a phenomenon from Okulovka*,
Born on the way and for the way foretold
A call from the Space for his spirit
To continue the great spirit's role:

A father – in his son, a scientist –
 In his successor –
A family alloy of bright minds.
Was Russia conscious: the God sent
 A fate present
To the Land of sins – for all the times.

* *The birthplace of the scientist, in Novgorod region, Russia*

* * *

What haven't we got – a real present
For us, born later to the world:
Pictures and books, rules and the order –
Gifts, left by the Roerichs to all.

From India to the States
They left a path on the Earth,
Making it humanely, with care,
Gathering people in the whole.

* * *
To Yuri Roerich

He studied in London, Paris and Harvard,
Crossed India and lived in this land,
Learned and spoke different languages,
Many people managed to understand.

The East to be absorbed by Europe
And the wisdom to prevail –
Not everybody has the fortune
To get over a wordiness, not to be vain.

* * *
We can't do anything else,
But to admire them,
And taking this way,
To thank the God himself.

Even if we have no money,
Spiritually we come to the East.
The mankind is native for us –
The Roerichs have proved it indeed.

* * *

To Yuri Roerich

They wanted to kill him in the tent,
At the moment of his creation light,
To shoot the knowledge saint,
With a gun to stop the flight.

Suddenly there is some voice:
"Drop from the table!" Yuri wonders –
He is alone. But hears the same
And then – a flash of lightning,

Some huge and vigorous power
Throws him on the floor.
A crash. Yuri – alive – unbelievable:
The bullet meets the wall.

It is said, it wasn't heavens' cover,
There was no God's protecting hand.
Really? But he was saved, in order
To write down his thoughts with his talent.

* * *

To the family and Yuri Roerich

Stop, Time! And tell about the Roerichs –
Born to be the future, they solved,
Like a far breath, came from Himalayas,
Mysteries and secrets of the world.

Tell about words of their mother:
"When a new star will be in the sky,
Go back to Fatherland!" – Elena
Ordered so to Yuri, to her son.

And there was a star in India,
To Russia was Yuri on his way.
He propagated much their ideas,
The sudden death took him away.

The Gods decided may be so –
To leave him on the hapless earth
As much, as they defined. For ages
The Roerichs'll be in future days.

An intellect, a greatness and a fire!
Time, stop, and tell about all!
They are of those men of wisdom,
Who so rarely are born.

And they continue to eternity the way,
Will Universe gift others in the Nature?
Sometimes a part of Paradise gives us
The God himself – to his creatures.

* * *

 On the occasion of 5-years expedition in Asia

The caravan with men and cars, and animals
Is on its way to holy knowledge,
And in the world so beautiful, immense
The Roerich family is bearing the torch.

Without bounds, limits and dismay
They lead the people forward boldly
And overcome all troubles on their way
Protected by the divine order.

And Yuri has a military skill
In combination with great courage.
And aspiration for unknown will
To learn leads like an arrow to a target.

* * *

The beautiful teaching of Buddha
– By Yuri it was reborn,
An epoch, broken, by wonder
In times lasting traces put on.

A teacher was called the man,
Who came with this mission, surely
He was by the sky ordered
To create a temple on the ruins.

* * *
What is the East for us, look, Roerich? –
A door, that closed is.
To Europe a crossed way,
A withdrawal from the eternity.

Who needs to live in prism?
Some mean, with vulgar spirit.
But can one put the freedom
In a shell? And stop with this.

* * *
There are twenty pieces of advice,
That Yuri Roerich wrote about humanity.
But if you listen quite attentively to them,
You'll be in harmony with world
 And with yourself.

The poems are written on the 28th of February 2002 in Sofia

Florence in May

I believed, that I'm a piece of paradise
Of music and of beauty,
When once my fate in May
Brought me happily in Florence.

In the feet of the hills of Arno – river
There lived the lonely inspiration
And the poesy and music – in one –
Were flying in the Spring mood.

The galleries and theaters, the ever world
In the art of the whole planet,
Probably, there is some prose in this town,
But it will be lightened by the Muses –

Of music and of love,
Of artists and theatre – fans
– You are a real dream, Florence,
A tender highway to the centuries.

Confession

Seaside, why those purest feelings towards you
Do not leave me in the capital city,
The taste of salty sea lips,
The happy voice of the birds?

The beautiful design of the seashells,
The secret of the mussels in front of you
And the sandy steps of so many people –
Appearing questions with no answer

I am feeling both wild and endless,
Unbreakable like you, seas,
Undiscovered like the secret to the sea,
Like a traveler without costs.

25– 26 October, 2007, Sofia.

Am I a Woman, Am I a Bird

My wife is a flight and a fight,
The risk is loading my insight,
Am I a woman on our earth?
Or am I a bird in the blue sky?

Possibly I am both. That is why
I cannot always stride on the roadway
And my flight to pure blueness
My spirit is keeping – in periods.

I am not shot, not hurt,
I am not taken to the bottom, as
The angel's area helps in me and giving me
An intuitive thought against the evil,

Protection from above, brain
 And quick reflex –
The last on is typical for every bird
And the battles have been won until today,
Because they are pointed to the truth

And graceful – as a bird's circle,
They are spinning around enemies and people,
But my path is always honest
And my flight is always up.

Whatever God, I say, has given me,
No one can take away from me,
Unrepeatable is my part in the earth –
It is divided between different worlds –

Once here, once chasing the heights,
I don't understand the low spirits.
Once I am a charming woman,
Than I find my path towards the stars.

25. October 2007, Sofia.

Her Majesty, the Muse

Come here, my princess from the sky,
Stop the glowing vehicle,
And with your angel song,
Touch my verse inspired.

I confess, I am nothing without you,
An ordinary beautiful woman,
With wife and own home,
Come, you are giving me wings.

You are the gift, you are Everything,
You make me different and you
Are tuning my instrument from the sky,
From which my verse is ringing.

You are my "me" in the universe
And it is your royalty that inspires
My magic in the words,
They are my power and authority.

They remain after me, fellow the others,
Tern upside down thy typical day
I don't object the sky's merits –
God, one touch is taking you to me.

30.07.2005, Simeonovo

Harmony

The nature is silent, and still says everything.
Glory is coming from the mountain.
The voice of the small, ringing bird
Is showing that we are birds in the sky

Harmony of colors, shades,
From the God's swing
Proves that he is still giving us the chance
 To survive peacefully, with no worries

The wind is passing as a touch,
 The river doesn't stop is song,
This is no lie without pretence
And to remain close to the ground.

30.07.2008, Sofia

The Rock

The rock is having its own part –
It is tripping the road, giving hardness,
Cooling the passion, in some troubles
It is helping us to become stronger spiritually.

It is making us feel for eternity,
Harder than our own life
And in order to be more human
It is good to be as a nation.

You cannot outlive the years
When the rock lives, it doesn't die,
Its life is easy and not difficult –
Support strength, but also stillness.

I don't want to be a rock in the nothingness,
But a part to its hardness –
Yes, let me keep somewhere in my heart –
To survive and win.

07.03.2009, Sofia

Novels

The Woman by the Road

/Documentary novel/

The gold autumn evening was wonderful, but the heavy bags in my hands took much of the pleasure to enjoy it. I walked slowly by the Simeonovo road and was just by the stop after the school, when the bus took its way noisily to Sofia. I abused in my mind, angrily crossed the way and put the luggage on a bench. Then I began to read one of the newspapers, constantly present in my bag, and deeply absorbed in it in spite of the dusk.

For some time I was sitting like that, but then I left in the air the fluids of someone's presence. Startled I raze my head: there was a woman, sitting by me. Not young. In a red jacket, blue trousers – these things were seen by me first of all. I had not heard her. She was looking at me.

I returned to the newspaper, but did not keep long at it. With the corner of my eye I watched the woman.

– Yes, she still was looking at me. And not just looking, but peering into me in a very special way, as if some magnet was attracting her to my person and she could hardly stop not to fall on to my neck. Her pose, so tense, was directed to me.

– Oh, my God! May be she is out of her senses? No, she does not look like that.

– Her face is intelligent, quite O'K," – crossed my mind.

The silence was too awkward.

– Why are you looking at me in such a way?

Unexpectedly for myself I addressed my direct question to the woman.

Instead of answering she came to herself that even jumped on her sit.

– Oh, sorry!

– Never mind, but still it's strange…

She did not give me the explanation for her look and tried to go around;

– Is there no bus for a long time?

– Not long. I missed it.

– It's pity. Sorry, what's your name?

At this question my common sense said to me, that this woman is a little bit "out of hers".

– Rossitsa, – I answered peacefully and began to wait for another sensational.

It followed immediately.

– Rossitsa, please, tell me how you spend you time – one day, just one!

That's it! – The wonder by the road. I could hardly restrain my laughter, but I got a hold of myself and with a well dosed humorous tone started to explain, that in the morning I first of all visit a bathroom, use W.C. and so on … Without any bad intention I tried to make her understand the absurd way of her behavior. My God, is it the way so ask someone? To my even greater surprise I got a feeling, that she absorbed my words. My humor got out confused. I stopped… I tried to see the color of her eyes, the dusk

prevented to me – every second it became darker. There was a gust of wind, our hair got tossed, the woman raised her hand and put in order ... my hair. She kept silent.

– If you are not a doctor or a phycologist, sorry, then you look to me strange.

– I'm a doctor. But it's not the reason. I wouldn't tire you anymore, it was too much. We shall not speak about anything, if you want.

– About anything? – I laughed. – The whole country speaks now about politics and you – about my everyday life! Why are you interested in my life? Why are you so kind to me? I'm sure, that we don't know each other, that makes your behavior unusual.

I felt, that the decibels of my voice become higher with every word. Her neighborhood made me nervous. I had to break her silent attack to me as to a to a being, that she seemed to take over.

– That's the wonder, – she said softly, – that we do not know each other, but you are a copy of my daughter, whom I lost in the airplane accident. Do you remember that crash with the plane on fire, coursed by a mistaken let out, when Todor Zhivkov so unscrupulously flied over it in the most criminal way, without doing nothing?! Do you remember? They wrote a lot about it.

It seems to me, that I see my daughter, that's the reason for every thing.

I was stiffened. It was my turn.

– Sorry... – I faltered out. – I'm sorry for everything, that I've said.

She nodded slightly; just now I saw, that in spite of the difference in our ages we looked very mush alike: white skin, the form of the face, thick lips, straight brown hair… She was not crying. Was it a doctor's training against death?

– And what is your name?

– Nadia.

– As my mother. Something pushed me to standup, without knowing what for.

– The bus, – she said.

– I did not hear. Instantly I took my bag.

– And you, Nadia?

– I'll wait for another.

– Another?

–Yes. If I take this, I shall not part with you. It's horrible.

There were no other people. The drier looked out surprised from the window:

– Hei, you, both – will you not get on?

I jumped in to the bus without feeling the heaviness of my luggage. The door closed and the bus run away with me. By the road there stopped he woman, whose was Nadia. Something, that I did not want to take, but that came with me itself, was her glance, truck by impossible likeness. What's the irony of the fate! The glance of the eyes, that I could not see the color, but that surely were motley, like mine.

The Principle's Tactic

The parent Penkov entered the principle office furious, with a clear mission – to punish his son's teacher, Mme. Nencheva.

– Good afternoon! – The greeting sounded more like an order. Principle Staneva immediately recognized the impulsive hidalgo, who would knock on doors to get a favour for a kid and she was convinced, to not let go further than her office.

– Good afternoon! – Sweetly and slowly replied the principal. – What can I do for you Mr. …?

– Penkov. My name's Penkov. I came here as a parent, who was horrified by the literature teacher, Nencheva. My son said she regularly threatens him with expulsion.

The principle immediately knew the kid, no matter which one he was, had been lying, probably to cover a mistake. Nencheva was a strict teacher, but a very correct and ethical person. There was no way that she would do something like this. There were no threats, nor panic in her classes. But to try to convince the infuriated father, who at that moment would trust only his son's words, was pointless.

– Which class is your child in, Mr. Penkov?

– In "8-b". His name is Vladimir Penkov.

– Oh, yes! I know him…

– Really? – exclaimed the father, who didn't catch the undertones in the Principle's voice.

Staneva really knew the terrible Vlado, who often gave hard time to Miss. Nencheva. At that moment, the principle decided to play a role.

– Yes, I know Vlado! He is good kid, but Miss Nencheva is young and sometimes very impulsive in her decisions. Of course, I will punish her, Mr. Penkov. Anyway, most of the teachers need to be fired.

– But Principle, the father was startled – Oh, my God! I don't want this teacher to loose her job! Just talk to her. I know that my son is not very easy, but expulsion sounds a bit too much for me. We are not at home and he walks alone in school-hours… It's true, some times I cannot stand him…

And the father started telling stories about his son's behavior…

The Principle listened to him with a sweet smile on her face and occasionally added something nice and gentle about the kids.

Mr. Penkov was lost in admiration. What an understanding Principle…!?

– Would you write a letter of complaint?

– Oh, no! I completely trust you!

– Thank You. I'll immediately take action.

The parting was almost amicable.

The moment Mr. Penkov closed the door, the Principle took a deep, relaxing breath.

– Another happy costumer!

She pressed the intercom button:

– Miss. Nencheva, are you there?

– Of course, Principle! – answered the polite young voice.

– Could you please come over? I need to tell you about my conversation with Vlado's father, who is twice as terrible as his son. You need to know that the little one lies. You must be careful and I'll teach you how to protect yourself.

Silence…

– Nencheva?

– Yes, I am coming – replied the surprised teacher.

– Are you surprised?

– Yes – she admitted.

– I was like you, at the beginning of my career. Now I know… Come, come…

Smiling to herself, the Principle started to prepare a coffee while waiting for the young teacher. They will have a nice conversation, exchanging ideas and tactics how to let Vlado – and the kids like him – to fall in the trap of their own lies.

Behind The Wall

Part 1

> *My little prayer to God:*
> *"God, you gave me brain and talent,*
> *Give me courage, honesty and energy,*
> *I will handle with the rest"*
> *Amen.*

Foreword

I must admit that the stimulus for all these revelations was a book – "Exchanging garbage for plums" – part 1, by Nadezhda Zaharieva (I red the second part also, as interesting as the first one, but the first gave me the stimulus). One very sincere confession, but I don't agree it entirely. I also admit that I read it at once in the Bulgarian National Library.

And I decided to be really honest with my readers. Even so from different angles, different points of view.

Everybody has its own suffered destiny, but in the real life there are common truths and common measure for regularity.

I will share this story with the public, but I'm sure that some people won't like it. My origin is entirely Bulgarian and my soul isn't ashamed from anything I've endured. The way, which proved my creations, was leading me to the wall of people, close to the regime of Tato (Todor Zhivkov).[1] After

[1] The leader who reined Bulgaria during the Communism. He ruled from 1956 to 1989.

1989 I published my first books and did it without expecting any benefit, but I won public recognition. Abroad. And I'm still winning it. This couldn't be possible during the period of "realistic socialism" in Bulgaria, according to Nadezhda Zaharieva.

However, I respect her not only as a human, but also as an author, but this fact won't disturb me in being an honest judge of the time and the facts which are true in my life.

Despite all the "socialism privileges" (money, houses, trips, cars), which somebody got, I personally think that the "real socialism" was good for those, used to get everything for free from the country, but it didn't have anything to do with the idealistic communists from Bulgaria who were completely different kind of people.

There were idealist before those people; I hope there will be some after them also. Some of them were brutally murdered, like Gorunia or the Bulgarian wretches.

Belene was a reality for those who were independent and freedom-loving. This was proved by my "journalistic" career, by my articles for communist magazines and the hope that I could do a breakthrough only by my talent. Alas. The only good thing was that the Party didn't "suck" me in.

I actually understood what it means to be threatened because of your honesty by the poor in spirit. And your only protection to be God and some people who haven't forgiven what is conscience during those years. I still call these people "alien humans" because of their ideals. (Many years

ago, while lecturing in the Ministry of education what I have done for the kids, some people told me: "During those years. You are crazy." May be I am, but I don't regret.)

My family and my clan haven't ever been engaged in politics. Despite this we have a relative, killed by a communist-policeman. We also had problems which remind me that there are vindictive people among the Bulgarians.

Elin Pelin wrote this critically and clearly: "The genius of envy is living only in Bulgaria."

And we all know that in his home village Bailovo, where he worked, he went to law because of his novel "Geracite". He didn't get a sentence, but it reminded him to his death. The reason for going to law was that some of his fellow-citizens wrongly recognized themselves in his characters.

In conclusion I would say that the forgiving soul of Nadezhda Zaharieva won't be my path to life, but the vindictiveness isn't the right choice. As you will see later in the text, I am quite irreconcilable person, but I still keep good feelings to Nadezhda.

ROSSITSA KOPUKOVA

* * *

And so, I have got all moral reasons to be proud of my origin and my parents and relatives. I want all my readers to know who am I and am I going to talk about. I will add copies of some authentic documents and photos. I also want to thank to intelligent newspapers like "Women's Kingdom", to the Bulgarian national radio and its program "Horizon" and personally to Daniela Iakova and Elena Vlashka for publishing my materials and talking in air about my family. They never asked if my parents were communists, as other people did.

I've got many reasons to sympathize to the Bulgarian Democratic Union. I communicate with many people from different political parties and I respect their political convictions.

But let's don't lead of the way.

My mother, Anastasia Petrova (her maiden name) comes from the famous family Pindracite from the villages Gurmazovo and Bozhurishte, which are near to Sofia.

Pindracite means "noble people".

Mihail Giorev Pindrachki – a robust, tall, hard-working and smart Bulgarian, married my great-grandmother Kremena by a deal. (A typical way for marriages a century ago). Kremena's father said that if she didn't marriage Mihail, he would have killed her. Then he was 17 and she was 22.

She told her father "I don't want to marry him, he is too young". He didn't agree.

Mihail Pindrachki became legendary for his honest, hard-working and rural prestige.

Then you couldn't divorce, even if you hadn't wanted to marry, but their marriage was the happiest the local people know.

My mother died three years ago, God rest her soul. She told me about her strong love with Mihail. He shared everything with his wife, even a candy he had received.

We keep a portrait of them. They look like characters from Vladimir Dimitrov – The Master's picture, but he didn't know them to paint their portrait.

My great-grandfather was an agrarian. Today Bulgaria needs more people like him, but there are few left.

Neither my mother, nor me grew in Gurmazovo and Bozhurishte, so we don't know much about the field farming, but Mihail knew all the details about it, he "breathed with his land".

When he had earned some money, he bought more land, not houses. And he loved his land a lot.

His house had two storeys – according to modern hoses it was very small. It was situated at the Gurmazovo's center. He also got another one storey house in Bozhurishte. The first one was sold by the relatives. The other one went to ruin and another one was built onto its old position.

Mihail was a good landlord, a good singer and he loved drinking a cup of red wine before going to sleep. He had strong moral and clean soul. He liked to ride his horse in his lands, just to watch and enjoy them.

He had a lot of agricultural labourers, who came from the villages nearby to work for him, because he fed them and paid them correctly.

He also had two racing horses – Krasi and Venci. He cared for them as they were his children. They always won the races in Bozhurishte and everyone wanted to ride them. When the government took them for the TKZS[2], they didn't endure the conditions and died.

Mihail was a well-to-do-man; he made a lot of donations to the Bozhurishte parish. He was killed by a policeman – communist very brutally on his field. For "thankfulness" by the communists. His action – to hit my great-grandfather with a stick of wood like a complete savage – reached his family as a curse. This was God's justice. You can lie to everyone, but God.

After the hit one of his granddaughters – Temenuga, ran toward him. She also past away. The murderer – policeman tried to hit her also, but he missed her head and hit her shoulder. She screamed and he ran away.

She took off her kerchief and bandaged Mihail's head. They hitch-hiked a cart to Sofia, but he lost a lot of blood and died in the hospital.

That's the end of a memorable Bulgarian during the formation of the TKZS. He was killed not for doing something bad; just out of mere spite. I will leave this authentic occurrence without any comment. I will change the direction of my story and talk about his son-in-law – Toma Petrov Traianov. He was the husband of Mihail's daughter – Vasilka and my grandfather.

[2] TKZS – kind of co-operative cultivation in Bulgaria during the reign of the Communists.

Mihal also had a son – Mileti, who was also a hard-working man as his father. Mihal lost a lot of children before Mileti.

Mileti was hardly quelled not to kill his father's murderer.

He was born in the village of Gorno Ilino, near to Bitolia. He was in Sofia, when he saw my grandmother Vasilka for the first time. She was visiting her aunt in Kniazhevo. She was hard-working, pretty and energetic and Mileti fell in love with her in very first moment he saw her.

Vasilka was born on 27 Nov. 1891. She wasn't just anybody and her generosity was enormous. I call her hands "blessed by God". They've created hundreds of hand-knitted rugs with traditional patterns, men's and women's shirts, knitted socks and slippers, whole carpets and lots of other things.

After she married, she left most of them for her relatives in Gurmanovo – nobody else had her talents. The rest we donated to the Ethnographical Museum and one small part I left for myself.

In my opinion, the Bulgarian history has not begun since 9 Sept. 1944 as some people thought.

Later, after she married in Sofia, there wasn't a hungry or thirsty man, or an orphan not to be invited to eat in her house.

I remember how an expert from the Ethnographical Museum – Mrs. Komitska and some of her colleagues watched what my grandmother had created and said words of thanks that we hadn't sold these great things to foreigners. These knitting couldn't be valued, they said.

My grandfather Toma was a great Bulgarian and patriot. If Mihail's family was rich and had their own land, Toma Traianov's was hereditary poor. They lived in Gorno Ilino, a village situated in the foot of mountain of Pelister. They were 8 children and there was no work for anyone.

When he was 10, his father brought him in Sofia to be an apprentice in a shoes workshop. He couldn't afford a better education. Toma worked for a couple of years and then went back to his home village to finish his education. He graduated from the trading school in Bitolia.

When he was 21 he received a summons to be a soldier for Turkey. (He was born on 20 March 1888.) Macedonia was still under the Turkish slavery. He and a group of his friends – patriots didn't want to go to the army and ran away to Nish, then to Sofia, using the cargo wagon on the train. This happened in 1909.

It is known that the Bulgarians from Macedonia was strongly supporting each other so the youths begged the travel agency "Toma Bakrachev" if they could emigrate, because they didn't want to fight for Turkey.

They were immediately sent to a ship for London as laborers. They were directed where to go in the England's capital, with its straight streets and identical houses. It very hard for them to find the address, but they stayed there quite long until they decided what to do.

There were a lot of Bulgarians like them in London and some of them decided to run away in Canada, traveling illegal on ships, leaving from the London harbor. So they managed to get to Toronto and my grandfather immediately

found compatriots there and in a few days he started to work in a bakery. Making bread was something that he was good at all his life.

He lived in Toronto for three years and he probably wouldn't ever come back because he started to work in a factory, he was awarded with a trip to New York and he had a nice lodging.

But he heard that in 1912 an army was formed to fight for the emancipation of Macedonia from Turkey and he left his untroubled life in Toronto. He bought two golden bracelets and a ring for his future wife although he hadn't got a beloved. To give her a gift from Canada. He didn't want to marry an American woman.

He traveled with some friends to Macedonia to join this arm. He was injured and operated during the battle, but he survived. He fought on different places and he received a military uniform and four medals for bravery, gift to him by the Bulgarian Government and King Boris III for his great services rendered to Bulgaria.

After these turbulent war times he met my grandmother in Kniazhevo, fall in love with her and unstoppably asked her aunt Kana to tell him where his beloved lived. At that time he owned a restaurant with a friend of him in this fateful Kniazhevo. And how did he head for his future wife? With a bunch of friends, in Macedonian way, with several phaetons, musicians and a flag.

My grandmother Vasilka and his mother Kremena was accidentally talking on a window watching to the square when they saw the whole procession heading from the hill nearby. They were wondering:

– Who are these men going to, Vaske? – Kremena said, but after a while she went numb: – Vasilke, it seems that they are coming to our house, coming for you.

So Toma officially wanted to marry her, she agreed and it was love from first sight. He spent his share of the restaurant in numbered days for the wedding and it was the biggest wedding in Gurmazovo ever. So the bride had to ask her father for some money. They rented a small house somewhere around the "Pirotska" str.

My grandfather started to sell banici and milenki[3] on the "Dondukov" boulevard. Two times a day they baked them and the business began to do well. After a short time they bought a house on the "Nish" str. and opened a water-melon shop. They were switching in selling and sleeping to keep the stock. They were also lucky in managing this place. Then they opened a confectioner's in front of their house. My hard-working grandmother had a lot of customers and many of neighbors were jealous, but my grandparents were unstoppable. With the money they scrapped together they started to build a bigger house, because they wanted to live from rents when got old. The times were such.

Unfortunately, my grandfather and a lot other people were cheated by a contractor – scoundrel who took a big deposit and ran away in Serbia. He was saved by his friends – Macedonians, his father-in-law also helped. The construction didn't stop and soon they built a three-storey house in the front and one two-storey in the garden, an old-fashioned washing machine, some outhouses and a garden. The

[3] Two kinds of traditional Bulgarian refreshments.

building wasn't very luxurious, but it was strong. They didn't have enough money after the robbery.

Their next business was a rented shoe shop. He paid his duties and became famous as the most loyal tax-payer in the whole community.

My grandmother worked a lot to make the interior of the house better. They bought some modern furniture, but her health decayed and that forced her husband to buy a small villa in Bankia near the famous mineral water spring. My mother and my grandmother helped him in completing the furnishing. She was good at doing the house work and he did the "men's" things. Later he bought some bricks to build a new villa, but the Second World War overtook him.

This small villa saved them from the devastating bombing over Sofia by the Americans. Their down-town house also survived. Two bombs were dropped over it, but they only hit the cement staircase and the roomers put out the fire.

After 9th Sept. Toma didn't listened to my mother's advice to sell his property and to buy a larger apartment in the city center although the communists put roomers there also. The Radio Sofia was proclaiming that the honest people's properties won't be confiscated. To him, his land was his life, work and pain. It was just a mirage.

His villa was robbed by the "Russian brothers" for the Home country's needs. There was nothing, but a roof and walls left there and it wasn't the only robbed in Bankia. In 1947 he was nationalized by the Law for the massive town property. He was only left with a one floor for living and for a very small rent. The old Law for protection of the

private property was abrogated and he became Nobody. Only some of his ex roomers called his respectfully "Landlord" and remembered that they hadn't seen anything bad from him.

Here I will tell something in addition – before 9th Sept. a Communist was living in his house – Petko Kunin. He was betrayed by his people and captured in my grandfather's house, but not by him. Toma respected everybody's ideas even when he didn't share them.

We saw such disgusting things. I don't even want to remember them. The roomers' children also growth there and they became typical "communist work class".

Left with no work my grandfather started to unstop people's toilets and then worked in the building. Then he was 65, but he kept his heart. Once he fell from a tall beam and broke his legs. Then he stayed in the hospital for months. His legs healed and he could walk again. My grandmother helped him a lot. He needed to use a cane in the beginning, but he succeeded.

My mother hardly graduated economics and was very hard to find a job. After some time she started to work as an accountant in a factory. She even retired there and they didn't want her to retire because she was their best employee. Her boss was a communist and he didn't even finish high school. He was a director of "Toplivo", his name was Kosturkov. He managed to find good jobs for his wife and children. They were all dumb cluck. This was Tato's "Red intelligentsia". Toma Petrov was admitted for a volunteer and got higher pension, but too late, but he lived his life with on honor. When he was 80 went in Bitolia to see his brother.

I will miss some awful moments from the "Toplivo" period because I feel sick when I think of them and I will continue my story with my father's origin. They were refugees from the city of Dimotika which was near Odrin. It happened in 1912-1913.

* * *

The carts are loaded and everybody is trying to reach some relatives in Bulgaria. My grandmother Raina Kopukova, her two brothers and her mother Rusa choose Mihailovgrad. Rusa lost her two previous husbands. Her future husband Dimitar Kopukov was in Sofia together with his sisters. The times were dark.

Raina's brothers were wealthy and quickly built a house in the center of Mihailovgrad. This house still exists there.

Dimitar from Sofia was an orphan. Firstly, he became a rail man, then a shoemaker and he managed to save money and to buy his first shoemaker's machine, but he still didn't have the last 100 leva. I don't know how this dream machine cost, but I remembered that he told me a story. One evening he was desperate and God helped him. He was walking and he spotted a bank-note that someone was dropped. He grabbed it and was a 100 leva bank-note. Simply a miracle. Tears appeared in his eyes. He bought the machine, rented a small workshop and started to work. In the room behind there was just a bed, a table, two chairs and a tab. Nothing else.

Raina's older brother – Dragne, came to Sofia to see his countrymen from Dimotika and saw Dimitar. He decided to meet him with Raina. He brought her in Sofia and invited them to a restaurant. Although Dimitar was poor orphan, he was happy, smart, hard-working and handsome man.

They liked each other. They engaged in Ivailovgrad. My grandfather went with a friend of him only. There wasn't a bunch of friends, he wasn't Macedonian. They married in Sofia and Dragne gave them enough money to buy a small neat house in the surroundings. So my both grandfathers were helped by their wives' relatives, but it never was occasion for arguments.

Dragne was a great man. Unfortunately, I don't have a photo of him and don't remember him because he died young. I remember his brother – Atanas, he and Raina were born during Rusa's second marriage. I am named after her – Rossitsa. Her husband was a revolutionary. His origin is from Koprivshtica. I will turn aside for a while talking for him. He was very brave man and his name also Dimitar. I know a staggering story for him. Dimotika was Greek and a lot of Bulgarians turned into Greeks, but Dimitar didn't want to. The bishop called him and asked him why. He answered "Because I'm a Bulgarian". The bishop was angry – "Can you see this white wall and the only black fly there. You are the fly". Dimitar said that's true because the summed was still to come. "When you open the windows, thousands of flies will perch there and I won't be the only one".

So Dragne wasn't his son, he was from another Rusa's husband. I don't know much about his father, but he was not a casual man because Dragne wouldn't inherit such a great nature. He was the largest donator for the building of the Ivailovgrad's high schools. He also donated his large personal library to the school's library.

Until the 9th Sept. his portrait was lifted on the school's corridors, but after that it was removed. The Communists didn't want to talk about the great humanitarian gestures of

the rich Bulgarians done before them. I don't know if this portrait is placed again now. My both origin's families' children and grandchildren are decent and public-spirited people. There are no drug-takers and criminals among them. There might be some arguments, but the families are strong and united.

The money change after the 9th caught Dimitar Kopukov unprepared. He had become a wealthy man, but he didn't surrendered. He built a villa in Simeonovo and the land he bought from a peasant. He also bought two habitations for his two sons and one empty land in the Modern surrounding neighborhood. It was something normal after all the years of hard work. He had opened a shoe materials shop, but before that he was a shoemaker and he has awards for this. He understood the needs of the masters and the craft.

The communist Law for the number of the habitations made us to sell. We sold the Toma's one after furious argument with the roomer. Because of this law my father – Vasil Kopukov, divorced hundreds of families. As a capable lawyer it wasn't hard for him, but didn't want to do it to himself and to save another floor of the house. They sold it. There is some left. I prey to God for health and what somebody had stolen he should lose it.

So the people from my family are hard-working. Who of them became rich did it working. Before the 9 Sept. eldest people used to say that God walked on Bulgaria then. It seems they were right. Communist was a synonym of a rascal. They only know what people they'd been and Bulgaria knows them and remembers them.

And now we enter into the socialist reality. I was born on 3rd Mart 1958. God gave me the talent to write, but then I

had no field of action and I'll tell in details what happened. The astrologists say that I was born as a person with humanitarian purpose. It also concretizes – writer, editor and journalist. And also as an ancient spirit – dealing with astrology. With no more transmigrations on the Earth. The astrology is a way of organizing the substance and who hasn't understood this has more to learn on his next transmigrations.

My spirit feels uncomfortable among the poor in spirit. I was destined to teach the others and not to study the chosen of me profession. The "communists' realism" frustrated my plans and because of my father this happened – he hated them.

I had also chances to leave Bulgaria by happy marriage. I've met some great guys from USA, Australia and France, but I didn't. I always wanted to happen like this. Accidentally or not I met them here, in Bulgaria. Maybe I impressed them with my look and my standard. I've learned foreign languages. I want to travel around the world and to come back. I've traveled all over the country, but I didn't love all the Bulgarians. I'm a Bulgarian, I'm proud of this and I represent it in my poetry. And I wasn't favored by the communists and I'm also proud of this fact.

* * *

Now I'm standing at the beginning of my literature adventures during the socialistic period. I'll open one very interesting and true door for you – my readers.

But before this I want to think about the revelations of Nadezhda Zaharieva in her book "Exchanging garbage for plums" about the writers and the alms. In the first part she tells that she's proud that her parents didn't left her any properties and that they were poor. On the side, I'm proud

that my parents didn't stayed poor and they became very strong persons – patriots, idealists. Slave isn't the one who has money and is a slave to them, but the one who obeys them.

I have no doubts about hers and our big poet Damian Damianov's honesty. I love him. I have all of his books and those I don't have I've read them in the library. I've also read all of her books. And I could honestly say that she's as talented poetess as him. She was his big luck, her "Virgin Mary" on the Earth, but I still have some concerns. Did he take some of the gifts from Tato like many else? And what about the others? Those who Nadia pointed and those she didn't.

That's why our talented intelligentsia was famous in Europe as the most spineless. Neither Czechoslovakia, Hungary, GDR nor the USSR had such presentation of gifts that the culturally damaged Todor Zhivkov gave to our intelligentsia to win more followers. This clever guy guessed how to bribe them. Do you think that Ivan Vazov or Iovkov or Elin Pelin received such gifts? Or Vaptsarov? His father was from Bansko and was so rich that the people used to say "What the King has the Vaptsarov has it also", but Vaptsarov had his own destiny corresponding to hi ideal. Very naive, but his own.

I can show many other examples. Like the "Harry Poter"'s author J. K. Rowling, an unemployed Swedish teacher in one very rich country who started alone. She expressed her talent in a café, divorced, with a kid. In Sweden and the other normal countries when you prove that you're a good writer you win by the selling of your book, not by government presents. And there are literature agencies searching for talents around the world.

A lot of mediocrities are grieving for Tato's alms for the culture. You have or you don't have a talent – there is no third option. I am also sad about the small pensions for the most of our greatest creators who don't deserve such a destiny, but the country is still not evaluating them. It's enough to success in the beginning, after that is easy. A producer to find you and to make money from you. Now this role is taken by the chalga-making companies. One of them has invited Zaharieva to write poetry that is intended for the truck drivers. She's not blaming herself, but I blame her – it's such a disgrace for her.

I do agree that a stimulus is needed. The man of the art is rarely a good manager and a dealer. I am also wondering why the Law for the donations hasn't passed. Some tax alleviations for the culture donators will increase their number.

Botev wanted to set Bulgaria free without having a cabinet and a villa, but his poetry still stands in the front of the Paris' Sorbona – where the most genius creations of all times stand:

> *"An evening is coming. The Moon is rising.*
> *Stars are covering the arch of heaven.*
> *The forest is noisy, wind is blowing.*
> *The Balkan is singing the song of the rebel."*

Vazov became a rebel leaving his rich house in Sopot. And he became the Patriarch of the Bulgarian literature. Days and days he traveled over the country to search for facts and stories for his works. And the "creators" of the Tato's era were begging for apartments, villas and cars. And a permission to hunt together with him – a great privilege. Great "creators", no doubt.

So let's go back – to the first years of the reign of Todor Zhivkov.

He was just married for Mara Maleeva – a young doctor. He was a famous drinker, a backgammon player, a gambler in the jerry-shop in Govedarci. He wasn't born there, but his wife worked there and he was an "everlasting student" in Sofia. The people Govedarci were wondering how a decent woman could marry such a degenerate. There he met a client of my father, Hristo. "We spent so much time together in this pub", he narrated. He helped him so much times when Tato was drunk. And he was often going to his wife to take more money from her. She was very nice person and nothing bad could be said about her. She worked 24/7.

"Then he became the First man in the country and once I needed his help. I went to visit him as an old friend. He pretended that he hasn't met me." He was a communist and the whole village knew it. They also knew that he was studying Law and he didn't take a single exam, but he helped the authors because he wanted the people to think that he is from the intelligentsia. And he wasn't the only one giving apartments and other things. The Communist Party subdivisions also. And we are wondering why this is continuing until today. It has become a way of life, a psychology.

* * *

So the new generation of authors grew up with such bearers of culture. "Lead me, o, Party, lead me…" – do you know the author of this is? I won't tell you, guess. Or "Pioneers, Comsomol and Communists are we together…"

Otherwise the life was cheap, we went on excursions. For people like me – the Soviet countries, for the rest – the

whole world. We rested on the sea and toured around the country. There were no thefts, but there was a fear among the people – of the concentration camps, of slanders. The word "informer" for me is a synonym of fear. There was a voluntary calumny, but there were also people who watched your every step trying to find clues that you are an "enemy of the country and the people".

My father (he was always a non-party man) was driven to watch closely the Jews in our apartment house. His apartment was bought by my grandfather Dimitar from Jews leaving Bulgaria. And my father managed to save himself from doing such a vile job, but until the 1989 he had a "red card" in his file. They didn't also enroll my mother because she pretended to be mentally defective. Then the motto was "Everybody versus everybody".

My parents didn't want anything from the rulers. They were brave and honest people.

* * *

My parents weren't maniacs about "elite schools". Although I graduated from the model "32^{nd} polytechnic high school" with excellent marks. Later it became s "Russian school" and all the capable teachers were expelled from it. I deservedly received the award "Vladimir Bashev" which were only two for the whole 1972.

I also published poetry in the "Native speech" magazine and I was appraised as a very talented by Stafan Mihalkov in his "First steps" column. During the high school I was always published there. Since then I know the unique and gifted poetess Petia Dubarova. The small payments were like "small wings" for the future big flight.

Mihalkov warned us "Be careful! It will be hard for you to success. The perimeters are already taken, but don't be desperate! And remember – you have a gift."

And he was absolutely right.

Even before my first contact with those predetermined environment I had the illusion of being accepted to study Bulgarian Philology.

I wasn't dreaming to enter the Faculty of Journalism in the Sofia University despite all my other publications in the press. There was a strong impact of the Party and there was no point of risking. With a clean conscience I can say that none of our gifted authors would ever published a book without the title "Communist" and this was true even for Damianov and Zaharieva. It was interesting for me to read a book about Damianov. There was a special vacancy for his son Iavor in the Wood-carving technical college. It appeared that the boy wasn't talented in this area, he was excluded from the school and his parents had to pay damages.

I thank his wife for these truths, but mine are different.

In the summer of 1976 there were 70 vacancies in the "Bulgarian philology" subject and only 33 of them were for the "normal" students. The exams were Bulgarian literature, Bulgarian History and a Political exam. After years I found out that in these 33 vacancies there were a secret list of "Our people" who were supposed to enter the University. In 1976 this list was given to professor Brezinski – a bright Party phenomenon in our history.

My Literature score was "B", History – "C" and Political Science – "Taken". I checked my written works. On my Literature one there was only one sentence in conclusion –

"Profound, but incomplete". Nothing else from professor Brezinski.

But he wasn't right. My every quotation was correct, the thesis – clear and I had no spelling mistakes. The theme was "Vazov's patriotism shown in his poetry".

The professor assistant wrote my work and didn't manage to answer why I had such low grade. My complaint had no answer. Because of this I didn't enter the university. We had the right to apply for only one university then. So my destiny was to become a laborer in a factory. It was a disaster for an intellectual like me.

Somehow I managed to transfer my marks in the Pedagogical institute "Nadezhda Krupskaia". My grades were the highest and had to study Russian to avoid the factory. Tato became an "intellectual", his daughter Liudmila – an "art expert" and the people like me – in the factory. Thanks God, it didn't happen like this.

The next year I tried to enter the "Bulgarian Philology" subject, but a new Decree was created – you may only try to enter one time.

I graduated from the Institute with excellent grades. It was a place where enter only those who weren't accepted anywhere else, but there were some great lecturers and they loved me. I got all the Literature awards given by a very active professor – Chavdar Ivanov. May he rest in peace, he was born lecturer. This Institute wasn't a university and I wanted a higher education. I could get it, but there were conditions – it could be only on the subject I'd learned, after one year of teaching and with a special authorization from the principal of the school you're teaching in.

I had to start my career as a teacher in a very unpleasant place. There were a lot of gossips and lies about me told by the other teachers. The principal was a woman – a very simple woman nominated by the Party. She was very scared that I could take her job and it was hard for me to sign a contract.

I took an external degree – "Preschool Pedagogy" in a branch of the Sofia University in Blagoevgrad. After the first year from 300 people left 100 and during the third year it was separated as an independent university and it became High pedagogy institute "Neofit Rilski", Blagoevgrad.

The philology's turn came last, after 1989 and I cost very expensive to the country, but I don't sorry it.

I coped with the pedagogy – I was awarded many times as a teacher, I also won scientific competitions. And in the Ministry of Education also. And they were paid well.

But I and three young colleagues weren't taken in a New programs Team because the older were afraid that we were better then them. And it was true. Another reason might be that these programs were highly paid.

I applied for a principal seven times and seven times I wasn't chosen. The principal had to be a Party member. Once the competition was stopped by the city major. They were afraid of clever people like me. Then I understood how to become an expert to the Ministry of Education, I tried only from curiosity and I learned how to "beat under the belt".

I also wrote in the press true facts about jobs saved for "our people" and again – nothing, but let me continue my story.

* * *

My grades in the University weren't excellent because I choose not to sleep with the professors. After graduating I decided to write for the press as long as I was a teacher. I could say it was a successful period. I wrote for dozens of newspapers and magazines – funny stories and serious articles. My poetry and prose weren't published and later I understood why.

I grew up as a teacher and as a writer and I met a lot of wonderful people. And a lot of mean also, but the life is such. I started with a brave material in the "Family and school" magazine in 1985. I exposed the terrible living conditions in the "Ran Bosilek" orphanage in Sofia. The whole thing happened accidentally.

We had to have a teacher's meeting in one of the halls of the orphanage, but in the last moment the place of the meeting was changed and some of us hadn't understood and went there. The principal met me and told me about the mistake, but I wanted to go over the building – a pure teacher's curiosity. He accepted and let me in. During my walk I saw frightening thing – the whole place was dirty, the walls weren't painted for years, the sinks were broken, old steel beds. One teacher came out of a classroom full of kids with torn clothes.

I wrote a very heart-felt article for "Family and school". The editor-in-chief Pavlina Popova took it personally and printed it immediately.

The Apocalypse started just days after it. Telephone calls, letters, threats and lies. Even my father asked me if this was a true story. Many people accused me that I actually fabricated the whole story to harm the principal and the school.

Mrs. Popova turned out to be a very brave and honest person. I went to the editor's office shaking of fear and she showed me several letters from Party leaders who wanted to send me to the prison in Belene. I begged the principal of the school I worked in to protect me (she was nominated by the Party, but she was a real human). A commission was established and it confirmed what I'd written.

We were pressured to write a refutation, but Pavlina said "No". More problems were found in this orphanage – the top floor of the building was rented by provincial party leaders' children studying in Sofia. Their rooms were luxurious – expensive appliance, import perfumes. Also all the subsidies for the orphanage were distributed by the principal and most of them were stolen by him and the people around him.

All this madness the magazine investigated for 5 more years – step by step. Nikolai Ninov wrote about it after 1989 in five consecutive copies of the "The dance of the Magi".

I call this man "an alien". He was threatened by the communists, but he never gave up. The case was also discussed on the National press-conference in Varna and became a national importance.

As a result of all this the many time awarded principal was immediately retired and the Orphanage was overhauled. There were no men penalized and I didn't go to Belene.

My family had donated many boxes with clothes and shoes to orphanages all around the country. Also drawing materials, notebooks, textbooks and other things.

There are more cases like this and will tell about some. I don't self-advertise myself. I just want to reveal the truth about this society which divided the people to "chosen" and

"not chosen" and embittered them. Toady we are still divided, but everyone has an opportunity to improve him, to work abroad and to decide whether to come back or stay there, but we still are far from the Western type of Democracy where you can rise from nothing. We are Bulgarians and every nation deserves its government.

If the Socialism was more bearable for the nation it could has survived as a way of ruling the country, but it proclaimed social division so its fall was normal. And many people still live with the idea of its return, but this is an illusion.

Now I'll continue with the facts about the education and the literature environment. For this story I got a small fee, but the most important is that I didn't suffer in a professional aspect because of the help of some people. I was promoted twice and had an offer to start lecturing in Blagoevgrad, but I refused. I wanted to create literature proving my gift and I succeeded.

Receiving the first promotion lasted for two years and I got a small increase of the salary. I made it from the second attempt and the reason for this is interesting. It was so because my wonderful written work wasn't written according to Professor Elka Petrova's books. The reader was Nadezhda Vitanova and she was an intelligent woman. She told me how to correct my work. The second version's mark was excellent. I passed the oral exam also and got the degree. It was my turn to deny Petrova's books.

I wrote a lot of critical and truthful articles for the "Orbit" newspaper. I confuted the ideas she had copied from Old Russian sources. My articles were true, clear and verified from the practice. Powerful men wanted to stop me, but the

editor – Mrs. Moskova, told me "Kopukova, you have many enemies, but you are smart and brave and I will continue to publish you whatever happens."

God gave me the power to fight against dishonest people and I am still using it. Many years after that Mrs. Moskova asked what was happening to me and if I am still the same. She's now retired and I can say "Yes, I'm still the same."

Elka Petrova was working on seven (!) places and she got seven salaries. During a big national pedagogical meeting someone told her "Mrs. Kopukova puts an accurate analysis over the problems of the Bulgarian preschool pedagogy and you can't confute her." Experienced people told me "You don't know what awful things happen in the "Pedagogy" section of the Sofia University. Graduation works of student disappear which she was in charge to review and then she publish a new book. These works aren't protected and indexed and nobody can stop her of stealing students' ideas."

But I wasn't afraid. I've written countless articles on social themes like the problems of the alcoholics, the "Night Trud" criminal page, the irregularities of "Balkanturist" and many else. And I still love most of my ex colleagues.

If I follow the chronology, I should include the events which happened before 9th November 1989. They shouldn't be underrated all the more that they are connected to my literature experience.

So, after the "Native Speech" magazine I started to visit the "Pulse" newspaper as the logical next step to the creative development of a young writer. Then I was 25. In parallel I was also publishing poems in the "Flame" magazine. The poetry editors in the newspaper were Parush Parushev and Dimitar Hristov, in the magazine – Rada Aleksandrova and

Vladimir Popov. I gave them my poetry and waited for months. They didn't pay any attention to me. The situation was the same in two other places – „Homeland" and "Sofia". It was such a luxury to talk to the editors. There was no clear answer for you.

Astounded by this behavior I was accidentally spotted by Aleksandar Ivanov who was an editor in "Io-ho-ho" – a newspaper for kids. He told me to bring the poems. I brought them and he read them. Then he told me "You're a very talented person. I'll tell you two things: first, don't be discouraged. Second – you need a good review by a literature critic to be published. And don't sag of the maxim "Over the bed to be glad" because there're a lot of ladies believing it. Don't despond. You have a strong character. The smart woman successes only by herself."

These were his advices. I was enlightened and very thankful. Dimitar Hristov once said to me "I don't know why Parushev isn't publishing you" and then I realized that I would need a recommendation if I wanted to succeed. I didn't want anything else, but an acknowledgement for my talent.

So I rushed to find a critic. They were usually at the café on "Angel Kanchev" 5. Now I realize what a lonely skiff I was in the Party's see.

I was introduced to Spas Spasov, Nikolai Haitov and Georgi Markovski. There also I met the permanently drunk authors Liuben Dilov – father and Georgi Dzhagarov, but it was impossible to talk to them. My supplication was combined with my poems and stories. The usual answer was "a private conversation with you". I was disgusted by them and I don't have a word strong enough to describe

them. The door-keeper told me an interesting poem, which explained all:

> *"On Angel Kanchev five,*
> *Capable or not,*
> *Everyone can be a poet,*
> *When sleeping in the right bed"*

And then she told me what she'd been looking for all those years. This formula was absolutely right, so I wrote two poems after 1989 about this problem.

* * *

Devoted to Zdravko Daskalov
Lawyer and caricaturist, humorist

I thank the bad man –
The mean man who cut my wings,
The underground who closed the door
On the road so straight and hard.
I thank to every evil man –
Who played against the rules
And made the short days longer
When I could walk forward.
I thank him for giving me power
From his, to walk on the Earth.
I thank obediently to the Destiny
For each and every victory.

And there is another one:

Destiny

Bulgaria's good poetesses
Don't live on "Angel Kanchev" five,

*For centuries its entry
Was always closed for them.*

*We exclude the "court" poetry
Which gave its result
And among the courtesy poetry
It let pass some minds.*

*And those who weren't "famous"
Or the heroes of the day
Were creating rhymes and rhythms
With the only wish of pure beauty.*

*And accidentally someone somewhere
Opened a locked drawer,
Took the poems put away
And just read them with passion.*

*And an art is coming from the words,
Things that no one has ever told before,
Feeling hidden to this moment,
A talent and poetical senses.*

*But somehow the time, the nature
Or the courage that have never been used before
Started to search their way to the public and the press
And opened their hidden lovely temple.*

*The years are elapsing quickly,
Unlit with poems so beautiful,
The good poetesses – the hostess
Leave them to just pass by.*

20th June 1996, Sofia

* * *

The first poem was published in my book "Is it easy to be young?" published in 1994 and the second is from the book "And God said: *Be a poetess*", published in 1998 with the help of the wife of a famous businessman from Varna. She was a colleague – writer and she evaluated my poetry.

I got a refusal from Rumen Leonidov from the "Torch" magazine – no explanations, he was keeping his back. Now he is flowing big articles with social importance in the "We – the women" magazine. Lachezar Elenkov and Petko Bratinov also had "other offers" to me.

One day I dashed into the office of Rada Aleksandrova and Vladimir Popov with a pressing request to give back to me my poems. They told me to come in two days although they didn't return MSS. It seems they were tired of me. I've never had contacts with these two. After two days they returned to me all my works with the works of another man – young humorist. Obviously, they didn't even read anything.

I was angry and after a while I understood who was responsible for the literature in the Central Committee of the Bulgarian Communists Party – Vladimir Golev. He was often "ill" when it was necessary. When I was searching for him, he was "ill" again and I had no other possibility, but visiting his substitute Victoria Dancheva. There was a section in CC of BCP, replying for every aspect of the life and the culture. I brought with me a poem, written by the Liubomir Levchev's son – Vladimir Levchev (He's now living in US) and the first lines were:

"A wall.
A flourish and a Moon.
Fa.

*A mist.
A Wall and a Moon."*

and it continued on these lines. I've always thought he's a mediocrity, but he wrote a lot of books which can still be found in the National Library as a confirmation of my words. I also brought my works and asked if I could read them. Victoria Dancheva agreed and I choose that one:

"Ordinary Things"

*Let there be more of what is always not enough
And I'll be satisfied and will stop
 Reaching the unreachable,
My senses will be always full of love
And my spirit will sleep with the sense
 Of the better future.*

*Let my words be heard like the word that's been heard.
Let my dreams go far and far away,
Let there be no magic in the ordinary day –
I just want to find the secret of love and life.*

*Let it be live, I don't want to die
Even the most banal thing, let me continue to dream
And with the things that are always not enough
I'll someday reach the top of the life.*

1988

 I published it later it "Is it easy to be young" in 1994. She wanted to hear another poem and I chose the love poem "Thirst", which was published in the same book.

"Thirst"

Like a fairy I want
To intoxicate you,
To absorb you with my eyes,
To hold you in my hair.

I want to spell you
To own you for ever,
To forget about the others,
To separate of everything.

The fairies are known
As a mean beauties,
But I will love you
Even if it hurts.

You can leave or not,
You can stay with me
Even if I transform into
The woman of your life.

1983

* * *

She was listening to my poetry silently. Then I asked her: is the mistake in me or in the editors. I told the "Flame" story and brought copies of the work of the young humorist and gave them to her. She was silent for a long time and then said "You're really talented. We are ordered not to mention in the work of the editors, just to watch and control them, but I promise to help you."

She sent a very angry letter to the editor of "Flame" – Georgi Konstantinov. He was a man who never knew what's going on. They had found my number and called me to come urgently. They tried to criticize me, but I confuted them. They were so furious that the critic Ivan Teofilov wanted to hit me so three people hardly managed to quell him. And I said "And then – forensic medicine, a document and an accusation. Don't think I'm joking – my father is a lawyer. I won't stay here if this insane man does something to me." He feared and went into another room.

Then I went back to "Angel Kanchev" 5, searching for a critic. I met Venko Hristov, may he rest in peace. We sit on a sofa in the hallway, he started to read and then said "Truly, you are gifted. I'll give you a recommendation." He set a date for a meeting, but he broke his leg, went into hospital and died there. Now I think that he was a diabetic or something, because you can't die of a broken leg. He was also working in "Flame". I got the hospital telephone number and called him. He proved be humane and wrote the recommendation for me. Then he told me "Here's my home number. Your recommendation is on my desk. Ask my wife to give it to you. We haven't been in good relations for years, but try to be kind and maybe she'll respond." She didn't. She was cold and didn't want to do anything for me.

I couldn't even think of publishing a book. The publishers were inaccessible for the ordinary people. I went to the "Youth" publishing house to leave a MSS for publishing. Took it back very soon when I saw the editor Nikolai Petev using someone's text as a pad. So I didn't manage to realize myself in the publishing before the 9th. I was only mentioned in Nadezhda Zaharieva's book "Exchanging garbage for plums"

I missed to mention another story – I went to Dimitar Shumnaliev about my prose and to Liliana Stefanova for a review. She hated him and told me that she could write it only when I write an article against him. I denied.

Years later I wrote a devastating review for a book he wrote. It was a flat and stupid partisan book mixed with erotic. Imagine his disgrace: he denied writing the book. I and the editor on the book market to ask the sellers if they had been selling it. This same guy is a close friend with Tosho Toshev, the publisher of the "Labor" newspaper. Now he's a managing editor of the "Night labor" newspaper – a "major creator" and also a "great man".

I don't hit the fallen man although many people do. When somebody is untalented I speak openly proving my every word.

Thanks God, Nade that the Democracy came. The freedom is a blessed thing, but we are living in another form of it, maybe because of the Communist's heirs and the split of the nation, something that's always been an obstacle for us.

Then and now, I've always had a living, but I'm feeling sorry for those who don't deserve to be unemployed, but I'm never sorry for the rascals especially if they are elder and it was their decision not to change.

My time has begun.

Revived

Part II

The first three books I published in the same year – 1994, as a gift from the Fortune. The money was provided by the firm "Astra" and by me – I sold one very precious violin which belonged to my father. I didn't want to make a profit from the book.

But why I didn't do it earlier?

In the school I worked the new principal was the last splinter of the Communism. The old principal became an inspector. Many years after that we were colleagues in the writing and she envied me for my intellect. (Her final mark of the university was D and mine was B+. She didn't even have a single day of teaching.) She defended me about the Orphanage problem and I mentioned her in my book "Your child is growing in front of me". Her name is Aneta Antova. The competition won another teacher – Mrs. Ilieva, I was tired of trumped up stories and it continued with Ilieva. The major was abroad and when he came back did everything he could to nominate his protégée – Iordanova. Because of the humiliation Ilieva was ill for three months.

She went off her job later. Iordanova was uneducated, but sly and became a principal. Before that she worked on 14 places and was dismissed from everywhere. I still keep facts and documents about this case. Five years our lives were hell because of her and I was the first who understood what she really was.

She was notorious even in the city hospital. 44 people signed the subscription to her with a diagnosis: "Charactopatia". Her crimes were countless: stealing of sponsors, supplies, dismisses, she had even opened a Tailor's in the Teacher's room. I feel proud of telling: "I respect myself for coping with this rabble." I wasn't hated by a single child or a parent, I was never to anyone. My father brought her to trial twice and finally she was thrown on the street.

A lot of people helped – good colleagues, parents who saw all the scandals. I had several meetings with the President of the ill children's parents' committee and other parents in a café. There I wrote the documents on a typewriter and they signed them. The doctors helped a lot with the defying of her psychological status. They also helped for the clearing of her relations with the doctors and the nurses and the pressure she did upon them.

I wanted the police to bring her to a trial because of the stealing of stuff and a lot of money and to deprive her of teaching rights. Then she had more troubles – her husband finally managed to divorce her, she laid a lot in the court and the trial was very long. I changed my mind about the future trial.

Now she's into another pedagogical sector and nobody wants to give her a steady job. She ran away from her job for a while, pretending to be ill and then she got a re-qualification, feeling that her days were numbered.

Governments changed while we put us on trials. She dismissed me, but I returned as a phoenix and as retribution. I won all my cases and voluntarily moved to the journalism. Things are now more liberal still more I never really wanted

to be a teacher. I saw a lot there and I'll keep many good memories. I still contact with some of my ex colleagues and remember many of the parents whose children I taught, but I admit – I would never choose Nadezhda Zaharieva's place. Battles – yes, but looking after a sick man – no. Everybody is born with a mission and bow her for her realized duty. Many times she saved her husband, the father of her children, one of the Bulgaria's biggest talents and I wonder if she knows the importance of her achievement. She is also in the number of the very talented people. She is a woman with different conception of the world.

And so, in 1994 I published three books: "Your child is growing in front of me", which is artistic and pedagogic;" A Bulgarian, wherever I am" and "Is it easy to be young". The first one was very liked abroad and it was annotated in the "Collection of the intellectual property", which was published in Geneva. It was also awarded with a golden medal on ESPO – 1994, where was also introduced to the pedagogical intelligentsia.

I had a great success.

I'm the same in the love also – I help young men losing their life orientation, advice them, but I don't fall in love. Then I say "Over" when they don't change, but the love poems remain.

They can't forget me, correct themselves and want to come back, but don't want them any more. That's me. And that's why I am not still married; I'm not an easy woman. It was my mother's biggest concern. And the men are afraid of making mistakes, because they know my father is an ex investigator, judge and a lawyer. It's their problem as long as

they afraid of the truth. My father left the Supreme Court, because he didn't want to be a party member. Also because most of the cases were settled by the phone. He was an acknowledged lawyer and many of today's best lawyers taught a lot from him.

Here I'll add a bracket – many ignoble people tried to outrage me laughing at my love poems, but not always love means sex, right? You have to be very stupid to think so.

I am very thankful to my friends – they helped me to publish more than 40 books of poetry and prose, stories, miniatures, essays and humor and I want to write more. I don't sell my books. I give them as a present to friends, colleagues, even people I meet on the streets.

A famous fortune-teller told me: "You'll publish, but you won't sell. Do it in aid of charity." This is my spiritual tribute to the people. And I'm doing it.

Soon after 9th I sent my first two books, signed, as a gift to Damian Damianov just because I esteem him as an author and man, without asking for anything. Then I saw my name in a small article, written by him in "Daily Labor". He was writing about young perspective poets. I wasn't from the youngest then, but he didn't know that. I didn't expect it and I was very happy and thankful. Even my father called me to thank him.

Nadezhda was wondering that I didn't want something from him. I admit, I wanted from him to help with the publishing of my book, but I didn't know that he had already helped me. Now I've just read "Exchanging garbage for plums". It's quite late, but reading the first part, I had the inspiration to write my confession.

With the help of the Fortuna I met Jordan Vatev. He was lecturing in the local library. I gave him to read some of my poetry and he was delighted by it. He wrote two monographs about my poetry: "The poetry of Rossitsa Kopukova" and "Towards the poetics of Rossitsa Kopukova". Some of the most famous critics wrote reviews about them – Marko Semov and Mariola Oagnianova.

I won several awards abroad. It's not vanity, just facts. It's fact that Vatev put my poetry just after Bagriana's, other research-workers – even before her. I am not embarrassed of saying it, because this is common opinion. Many horizons are opened for a lot of young writers and the older authors can't darken them. Of course, my estimation is a summary. Bulgaria is a spiritual country and has a lot of talented people.

It was cruelly a party to decide the destiny of the talents. Because people like Victoria Doncheva are rarities.

I've always feel social responsible and this appears in my poetry. I've never read "Party poetry". I am too just and freedom-loving, independent, strong-willed and lucky.

I have strong friendships among the journalists and the creators. For more than 10 years I esteem Donka Ganeva – she has no disharmony, problems. There is just creativity and business – media and advertising. Her partner is one wonderful man – Stefan Tambuev. There I met after so many years Pavlina Popova and we remembered our common past. Donka's husband is Jordan Ganev; he has great talent as a journalist.

I had great presentation in the National Library; in TV shows.

What I expected to happen when I was young happened. But I don't have in my biography a column – "Man I've slept with". I participated in two literature unions and I left them both. I never took any "gifts" and I wasn't favored by anyone. But I had such great luck to present my books abroad and to have such big reputation there.

No one is a prophet in his own country. This is true, but I don't think of leaving it.

Elections are coming. I will support again the Democratic idea; it seems clean, human and true to me. Everybody has its own weaknesses, keeping the right direction is more important.

FIGHT for your rights.

I'm doing it. Don't give up. Fight clever and brave. Bulgaria must survive. The creators also. Don't live with illusions and blocked memories. And don't hate yourselves even when you have to decide an argument.

As a final, three poetical greetings from me. I love you!

The river of my days

The river of my days isn't one of those,
Which hardly drag their turbid bed.
You can spot the river of my days by her mouth.
There are underwater rocks;
 The bed is steer and flat.

The river of my days has its own idea –
To caress, to wrap everything that's inside.
The river of my days is waiting for its sea
And the sea will engulf the scars
 Of everything passed by.

*From "**A Bulgarian, wherever I am**"*

A way of traveling

My horse is bravely galloping through the days,
Furrowed with different surfaces,
I pull the rein after them
To reach the endless future.

I don't know if I'm happy.
Who's wondering, when rides,
But being a rider – I am good at that,
I've learning it long and hard.

Well, I stop sometimes, only when
The horse is drinking water – to keep on
Running and then I ask myself –
How the walkers walk in the grass?

And can you breathe calmly on the Earth,
Is the beauty really wonderful?
Does the grass smell sweeter today?
But the horse was ready to continue.

From ***"Is it easy to be young"***

Clearness

The world hasn't been divided today,
All the lands has been discovered.
Now is everybody's chance
To leave his message for the future.

And some didn't understand this
And don't live by the rules.
But has the Earth been ever better,
Has the Earth been ever peaceful?

I want here, in my country
To live and to create.
To do something for my living,
Not somewhere to be lost.

This change of ideas
I want to be stronger.
Everyone has its own shores,
Everyone has its Home country.

From ***"On the road again – in Bulgaria"***

AUTOBIOGRAPHY

Rossitsa Kopukova, born on the 3d of March 1958 in Sofia, Bulgaria, is a journalist. She lives and works in Sofia. She is an author of 32 books of poetry and prose. There are 2 monographs, written by a Doctor of philosophy, a poet Jordan Vatev, who was awarded in the USA as a "creator'2002": the first one is *"To the poetry of Rossitsa Kopukova"* and the second – *"Poetics of Rossitsa Kopukova"*. There are also a lot of reviews of her works, as a part of them is united in the book *"A view to the creativity of Rossitsa Kopukova"*. The monographs and reviews are published in 2001 and 2002 in Sofia. Her poetry touches eternal world themes and persons, love lyrics, social poetry.

Her works – novels, essays, articles on different problems of life, ware published in a Bulgarian press. Rossitsa Kopukova was awarded with the international prize for poetry by the European poetry institute "Aldo Moro" in Italy, Lecce: the I prize /2001/ – the IX prize /2011/. Her book "Your child is growing up by me" /issued by "Gilik" publishing house in 1994, Sofia/ was mentioned in the annotation in the collected articles of the Intellectual property, Geneva, Switzerland. She began her carrier as a teacher, then, in 1993, she became a journalist. She can speak French and Russian, perfectly deals with astrology. She was a guest of some radios and TVs as a speaker on literature and astrology themes.

Rossitsa Kopukova took a part with some of her poems in a competition for poetry in English, presenting her books:

"***Revival***" /"Roksana" publishing house, Sofia, 2001/, "***A path from the East***" /lyrics, "Roksana", 2001, Sofia/, "***The Heart of love***", together with a poetess Natalia Ermenkova /"Roksana", Sofia, 2001/, "***Poems about Elena Roerich***"/ lyrics, "Roksana", 2003/, all of the translated in English by a poetess Natalia Ermenkova, known as a translator in Engish of Bulgarian poetry for a lot of Bulgarian editions.

Address for contacts:
Rossitsa Kopukova,
ap, 17, floor 3, blok 10,
Zona B-18, Sofia 1309, Bulgaria

CONTENTS

LYRICS
HALLOW, LIGHT
The play of the wind – 7
*** There is a small child in me... – 9
The spring of inspiration – 10
*** The proved truth hurts – 11
The pearls' mystery – 12
Before waking up – 13
The spring wind – 14
Spring wind – 15
Evening prayer – 16
The colors of love – 16
*** A family-tree would not forgive you... – 17
*** I don't like black words... – 17
*** The pseudo friend... – 18
*** Tell me about this country... – 19
Sky city – 20
The autumn fall – 22
Erato – 23
Honor – 24
A yard in Simeonovo – 25
Love, Love – 26
Learn Your Lesson on Earth – 26

POEMS ABOUT ELENA ROERICH
*** You are not a goddess... – 27
*** You are an inspiration for Nikolay... – 27
*** The New era herald you are... – 28

*** You ask your teachers... – 28
*** Elena, you were not a god... – 29
*** You crossed the continent all around... – 29
*** You worked for Buddha... – 30
*** You were a helping hand... – 30
*** Visions and dreams to you... – 31
*** In the conflicts of earth hostility... – 31
*** Elena, you are an example... – 31

THE POEMS ABOUT THE ROERICHS
*** The life is a sensed beauty... – 32
*** Mahatmas were good teachers... – 32
*** She, beloved by her husband and sons... – 33
*** The beautiful is always good... – 33
*** She crossed the world headlong... – 34
The dreamed town – Zvenigorod – 34
*** Born in the picture of Nikolay... – 34
*** And came the promised help... – 35
*** The Sun town, the wonderful town... – 35

A PATH FROM THE EAST
/11 poems about Roerich family/
*** There were three wise men... – 36
*** He was a phenomenon... – 37
*** What haven't we got – a real present... – 37
*** He studied in London, Paris and... – 38
*** We can't do anything else... – 38
*** They wanted to kill him... – 39
*** Stop, Time! And tell about the Roerichs – 40
*** The caravan with men and cars... – 41

*** The beautiful teaching of Buddha... – 41
*** What is the East for us... – 42
*** There are twenty pieces... – 42

Florence in May – 43
Confession – 44
Am I a Woman, Am I a Bird – 45
Her Majesty, the Muse – 47
Harmony – 48
The Rock – 49

NOVELS
The Woman by the Road – 53
The Principle's Tactic – 57

Behind The Wall – *Part 1*
Foreword – 61
*** And so, I have... – 64
*** The carts are loaded... – 73
*** Now I'm standing... – 76
*** So the new generation... – 79
*** My parents weren't maniacs... – 80
*** My grades in the University... – 84
*** *I thank the bad man...* – 89
Destiny – 89
*** The first poem was published... – 91
"Ordinary Things" – 92
"Thirst" – 93
*** She was listening... – 93

Revived – *Part II*
The first three books... – 96
The river of my days – 102
A way of traveling – 103
Clearness – 104

AUTOBIOGRAPHY – 105

www.ingramcontent.com/pod-product-compliance
Lightning Source LLC
Chambersburg PA
CBHW072216170526
45158CB00002BA/628